Carbonate of Copper

Carbonate of Copper

Roberto Tejada

Fordham University Press New York 2025

Fordham University Press also publishes its books in a variety of electronic formats. Some content that appears in print may not be available in electronic books.

Visit us online at www.fordhampress.com.

Library of Congress Cataloging-in-Publication Data is available.

24 23 22 5 4 3 2 1

First edition

Cover photo: Russell Lee (1903–1986). Type of dwelling of the lower Rio Grande Valley, Texas, February 1939 (detail). [LC-USF34-009758-E; LC-USZ62-131737; LC-DIG-fsa-8b38494]

To make sounds rather than what sounds to make.
—Pauline Oliveros

Houston • Brownsville • Matamoros • McAllen • Reynosa • Marfa
March 2020 • February 2021 • August 2022 • January 2023

Contents

1. Desierto de Chihuahua

The dead are the imagination of the living. And
for the dead, unlike the living, the circumference
of the sphere is neither frontier nor barrier.
—JOHN BERGER

Hangman

Green in the glade where the forest infatuates

where the children dulcify before they unnerve

and vanish from sight in the story

I tell to perpetuate in gray

are the callous mobs that occupy

the frangible hour of my crisscross

hour of my hunger to know

hour before the clouds irradiate

before the season arrives

with its pine and hazel

limit or line dividing

my easterly heart from a body

elapsing in garnet light

intended to banish

my lesion and thrum

And because the fable

must end in demise

said the sparrow hiding

inside the human voice

in long-drop throat

for the missing word

for all to see the division

of woods into flammable parts

and my mother homesick

for whatever there was

in deranged syllabics

and manic cackle meant

to choke and to mortify

as though she'd been given

a chance to come back

her ashes in lunge and recoil—

the accordion keys in major scale

Macula

Left-hand collision akin to the binary stars

 from a neighboring galaxy.

Right-handed x and x I met my mother

 plyometric in our belligerent alliance

our society of assault. My father

 heedless or headless but abracadabra—

my optometry of sleep. Here is the handprint

 and punishment when Jack be nimble

with my skin to the pledges of day in little

 patches of sun a macula a monster.

I so delighted in cascades of light to counter

 the Pleistocene age in fast-forward

tar pit the hills the hills the alleyway

 my newsprint corduroy and cottonmouth

when Friday morning air-raid sirens bellowed

 and I am every one of us in single file.

I'm of the earth convulsing in hallucinated headlights

and I stay within the dotted lines

alone at the end of the asphalt and beyond

the palm tree and sycamore in

proximity of broken windows where I wonder

whether God is condemnation no matter

the saint for the sake of my error. I was already

lost to fortuitous speed and accident-prone

in exultation ahead of the mastodon age because

I am falling now from a branch of the loquat tree.

Night Festival

To reach the night festivities I press against the celebrants

an abbreviated symmetry with me at the lower end of the hill

in a synthesis a corporation an exile of bodies in danger

I fear who know I have no business on the premises

or I fail to comprehend the intimation of despair

or I belong to no undercurrent of this circumstance

or what I draw instead—now the universal grid

now a pixilated vista—configures no permission

even as the mob begins to dissipate

 and there is my father

with his remorse imposing as the Andes

 above the great mountain savanna

his innermost ensemble of cells my father

his subordinate and metallurgic heartache

 all the microtones of Bogotá 17th locality

of my father's amphibian electro-cardio dissection

 alien puppetry his Gaspard de la Nuit

late lesson of his road mirage science he says I'm

homesick for the material contradiction of our kin

 among the living long after the land

overcame my conformity but please

 spare this from your mother

from her propensity to disappear over time

her 4 cardinal points in rapid alternation her lofty

decibels and coffee-milk austerity saltine

her solitude in newsprint apocalypse or index cards

her Billy the Kid Salón México Wilshire Ebell

Pedro Armendáriz Yucatán-peninsular

recursive close-up—*¿qué hora es?*

my father says *apúntalas* the words *ignominy* and *escrow*

 too late or unspecified on the subject

of wake time surrender phosphorescent

in the dimming light of extrasensory

encircled—body before, body after—

I had for my heart a perfect measure

 to justify the untimely turn

of my neither known never noiseless

and I had for my heart in the age of consent

a little loathing I had a coin that fit

the slot I had my compound fracture

declension of pain and deflated lung

irregularities of color But I know

now the mistakes of my ancestry

in the style of my birthday venipuncture

and poultice for my chest infection in the slide

transparencies of my naked limbs and chicken pox

that foretold the phlebotomy of all Erie County

I had now in my ventricles the great nebula of forgetting

and the abrogated law no longer larger than life

January Song

ribbon of day graced with

valerian and hemlock

with a numbness of notes

in undetermined order

after freeze and flood

of the January sprawl

and a pulse gone weak

in soft despair Was it

any wonder or wider

than a hill Was there any-

where else but the great

windblown fitful blur

abbreviated zigzag in

half-insane ascension

any one of my sources

distorted or faraway

enough to be a feeble quiver

of wing and the remaining

stars at dawn in dull

orange I wanted mostly

to know once for I was

a boy soon overtaken

by the world when

it ceased to bewitch

or to be more deserving

and upward in swell

the lowest rumble

of another cloud form

at midpoint Or was

I prone only to sing

now a spell of lemon

leaf and in view of

all the red anemones? ~

2. Orphan Hill, Presidio County

> The ability to consciously draw one breath
> after another.
>
> —AUDRE LORDE

Lung Compliance

If in my tangent I turned contagious

some one of eleven exceptions

nominal as I am when lost

now in the wave glide in my rattle distraction

maybe the atmosphere

held in the fold a feeling of elastic measure

I was pliant in the cellophane green grass corridor of sleep

and departure proximate but some thing conspired

so that my destination

was to the syndicate unseen as footstep turned my knees now

obliged to repel the pavement

 sound of sand in multiples of 3

accent of a heartbeat

 point I was given to demonstrate unable

only known in my foreign burning

 movement of muscle and bone

suddenly obvious a steeple a forest

prohibition a star point

but so too in the great monument this vowel

 and sovereign name

 name of estuary

 name of hillside

 name of battle cry

 scene of the discarded

 be gone

 beheld

 before I was born

Litany

Tonight the far side rekindles I first inflect a form of downward

dismissal in counterpoint given to unleash now

at the water edge with Graciela she notes

the feral horse so treading its head above water a carbon clot

to tell a place apart from my everyday reversal

make the late hour precise against fugitive company arrangements of fire

that radiate in grains of emulsion as from that surface

my forebear a phase insurgence surrounding us

in a column of water and spray ghost emaciated now

appearing in human form coarse hair a night shade tangle

overgrowth that proliferates so brutal it was time to intone

the litany: imposter of ashes and rings

imposter of the returning solar outburst

imposter of wintergreen hour the desert grasses

imposter of no one home better luck next time

imposter's degenerate hurricane sleep

imposter's knife dissecting edible parts and forgotten bone

imposter's debt to the riverfront picture sexless

imposter hand to throat

imposter of spreadsheets and post no bills

imposter absent of arms this wide enough to circle the lately enabled arrivals

impossible to angel the infamy of the imposter's grandfathered law

 allowing the twin imposter to pontificate on subjects pursuant of light in the

 hemisphere—sshh, be still—another affirmation

Remainder

I came to know it was my turn now to disintegrate

 below the tangled mesquite
and whether there was ever a story to begin with
 outline of a man

in deference to the pain that tells in night cover a boy
can learn to modulate petrified on the highway

in scale in sequence in phase form evanescing
liquid inclination in the physics of sand

unresponsive strangers here they are the barely living
and what they do to endanger
 is no talisman proper to sorrow's

material disappearing
haze that hovers

as fine as satin thread

when land met sound

in time for transformation

on the horizon line any semblance of pitch

or rustle the reflecting pool

vibration off the road

blood surge clicking in my vein

at the temples plume of myself

effervescent in the field further

amalgamates to the tonal brevity

keeps me safe in this world not

alone in the company of my wish

fulfillment bright keenly in quench

cascade in bantam advances

Ordinance

Based on a true story each morning was a pandemonium

that allowed me to define after days of unburden

when minutes transpired in the pyramidal world

like this or like this a solitary lamplight

flood of hope below the overcast

sky and palm trees in pairs pressed

against the still early hours of Brownsville

—winter rain some wind dog-song

receding in concert with a motor idling

vague now beyond a bend in the *resaca*

for all signs must go now no matter the ordinance

protecting speech so long as residents were

determined to display them near

the orchards and checkpoints Or rather

it was now the species of time Ann Lauterbach

likens to "a murmuring reprise . . .

a cicada stuttering the air" inclined

to dispel the sunrise panic of parrots

my reason a keen or a kind of riotous

adoring so configured in colored slashes

cut in blue and green consensus swooping

red-crowned and yellow-headed loud

crack that makes meanwhile demands

for me to exalt and with them to magnify

Speaking Part

I leave something out another form of refusal the vacant field

arteries upright the brittle deciduous branches

my hands so far in the foreground cages and bleachers

shadow shape in woodland green awash in camouflage

pattern my twenty-first century combat desert fatigue

was it Monsiváis who wondered whether

we understand the manifest to mean

not always in agreement unlikely diagonals

at a distance in middle gradations

estimated time of arrival for the descending sky

in softer assertion where is the vanishing point

blue arrowhead maybe of negative space

in the cloud cover freed from my speaking part

I spindle and chant ash orioles of fire

face-to-face with my species in thick motility

little vial of neurotoxins tick ticking in the vault

now a whistle and bark now the larynx

contracting my legacy of cruelty and kindness

fourfold pattern of my appearance my ability

to oppose the function of persons in coherence

of a scene bursting at the surface I come close

except in passing am I brought to bear

Citizen

Supremely alive to the letter

to the shifting

temperature in attendance of breath

of ceremony heartbeat footstep fugue state

varieties of action

attuned to the moment in profound

unruly blush for the private

distortion of a sentence safe-kept

now a middle distance between two

verifiable fires in the axis of time

earth afloat in the foam of it prospering

host for lower vertebrates

undead slow undead very fast for the sake

of appetite afterlife alliance

Witness

I was designed to describe
or explain and to formulate
a principle in practice. I was
destined to be outside the audio
coordinates not apart
from the sovereigns whom
I convince the science is sound
the medication approved
my plainsong in the atrium

*

I strike you so to speak as
venal in my great desperation
begun as the accidental
engine when I was charged
with so much malicious
listening enough as to

mourn your village your

guild and whether or not

to agitate if to admit

an opening for popularity of

the most popular item in

multiples of next-most-popular

*

I train the great invisible system

to make of my voice a spell

but lacking in ability to scale

—scale magnified for audience

in mellifluous delivery

the best competitor I split-

second back to my genius

or to little margins of error

Grassland

Flax color patches of flash-flame

 vast little grassland

disturbance come

 in splinter light

intractable

*

 morning dispersal

on encrusted earth

 in gravel shade

casting mineral

 hold given over

to whatever survives

*

 misgiven views

in diagonal glare

 to the far mount

above the patter

 of pronghorn

lured beyond

 the lashing Tyvek

house-wrap

 from a single wide

exoskeleton

*

 over winter disruption

given to proximity

 long unbroken

underspread

 of ground

in miles

 to the great elevation

the other name

for eye and throat

for land tilt

 delivery

*

here is the fiend

 of family

ferocity

 here is the god

so reversing

 genesis

as again to grace

 once-broken

blades of agave

 with blooming

Vehicle

I tell Lalitha so we found our way to the river look there : giants

hovering in a slow cinema of desert vegetation

ash-grey buckeye bark net-leaf hackberry branches

giants yes extraordinary all maw mud slime

but here is the catalog I tell Lalitha irrelevant thing for a night terror

that makes of empty life or spatial form whatever counterpart

able to agitate something inside out:

reptile notes to the Mesozoic symposium

mandible coupled with a widening of skull

cascade of sweet cakes a hedgehog

aqua-colored gel a kickstand handlebar and peddle protruding

bloat-explosive armadillo army barrack

torture wheel they nominate for the rotation sibling a jungle gym

lever crank and flatbed letterpress dismantling

in unspecified space now cushions a free fall

color of laundry detergent bubblegum and cottonwood

willow soapberry all the firearms

so surrendered by the nativist brigades

as to offer a moral to the story in conflict

with the element my anamorphic lens obliges

Immune

attention to what could anyone have said without

a form of certainty inside the edges enough

attachment all matter emergent here at hand

so I ebb suddenly once immersed I make a circle

I leave a stone now for a federation of my kinfolk

hands a transitive property so long as all arrive

in swarm and seething weight and spring I confirm

or subordinate indivisible from my forefather

carbon ignition insufficient to my surging arteries

and heart's reticulum everywhere by the millions

covered with a coating reciprocity never long

enough to be sovereign little episodes protecting

one of three behaviors all pitch and amplitude

stir blend or furnace in sequences of gas and liquid

fed to the atmosphere deliver me from decease I'm

the microsecond alternation I'm the speed of foam

Residence

From paralysis of sleep and lamentation

left shoulder right arm

unable to discern which

is which and who

the figure exacting to know why

the heartbreak in hiding

encasement of wax a hovel

tiny aperture viewfinder

they're here the polyglots

Grayscale

Beam of light an empty room no not empty

cloud cone circle suddenly a set

and somebody suspended there asleep

animating with alarm the household

objects in flush focus Point being

my right ventricle severed whirlpool

and my motor cortex uniting at a higher

pitch the nearly inaudible hiss

with a bass-line click of burning

surrendered self Outside there's

wind in the palm trees a far-off siren

turning on Adams a five 'o clock

branch dragging the asphalt also

a single leaf concise in sidewalk

tumble If you were prone to

forgetting a detail or direction

here are the scenes before sunup

a sound source television

grayscale gunfire in strains

from a time I recognize but not

as mine The bark of men in chain

reaction bark and spit and menace

in speech I was barely awake I was

barely even a boy my mother preparing

for work already I knew the warfare

it was for her to inhabit the volume

and idiom of skin out of true

or incompliant Prior to this

scene where she returns in half

light despite the prohibitions

a morning contains in sentences

that fail even the swelling oriented

to the audible horizon Redacted:

herein waiting for the whereabouts

of father in lifelong debility

of earth in the coercion of a child

given to search for it anything

In Person

My effigy in bronze across

the front lines excluded

from the parable

suitable for action rather

I think now in forever

present wonder do I voice

the discerning note

insane in the separation

or rather none between

tangle and action

between right

of entry and ritual

for the wartime world

overbright on

my birthday

hour entangled how

will I ever obtain

again my bearing if

I tell the number

akin to my displacement

and whether I was

accountable who among us

in defense of the builder

with tactics appealing

to our vanity

area of my square

on the hypotenuse

perplexing double

pull of self-denial

of shade and scale

I am inside out

for a form of life

in person in open air

brutal little side

of my apologetic

fold I thought

I knew to be hospitable

but in the overcast

was my reflection

I entered the immensity

of my whereabouts

I kept losing things

in winter memory

foremost please find me ~

3. Milestone Obelisk

*Listen, I've heard of this countable, nameable thing
we call an individual. But must we sustain it?*
 —JAY WRIGHT

Carbonate of Copper

in the hours I was left to the elements sorely
colorless labor evolving facts of a day

days now deficient in matters of fact
so many attachments of the tribe

to this stupefying circle it burns
a new image of the earth disabling

the view from nowhere

 am I unsheltered
and so out of time as to wonder

does my face defy its aim on end am I
the architect of this very small

thing I derive or refuse from the seven
descendants

does a landscape here

obtain as when there was food the field
abundant sun summer green

river valley chestnut little balm
border milestone

 came the builders
of a sudden identical twins at the sugar

mill it has a window overlooking
the carbonate of copper on shapes

predictive in the wireless ether

Impasse

On land inclined to ignite I was given to wildfire

to night sweat to ash-covered

clocks incinerated

photographs. I attended the wakeful

recital now —triage arrest

distributive shock—

in the scales I pursued

from the school of aftermath

and hearsay.

 I amplified

my refutation of the number

for alarm for the enabled

scenes of undeclared cargo

rumored to be gold

in hours for the eldest

and the undersigned.

 I found myself

disowned or missing among

the persons I berated

but to whom I was beholden

relative to the sound

of something badly mired at the far

end of my faculties

last brief leading maybe already

led to the first abandon

and later admissions

in the years I delayed.

 Was I

an embarrassment or danger

with my emergent properties

at the impasse and subject now

to no other law but to name

the orphan counseled in my care

or as when to play the ocarina?

Anyway

Even in distress I recovered the once beheld attendance

my name or designation

 proxy knuckle tongue

and tonsils

 in clearest profession

 in tiny quivers

my skull

 a cloud the great reservoir

only now a consequence

of light and heat

and color

 tang of cedarwood

in lowland proximity apart

 and by commission

for anyone else to count

the season I commanded to tell

what was out

 of the question anyway

 at that point

 nothing so much

as for the stranger I became inclined to half-light

 favoring persons

I knew only or barely

 at a middle distance

but as unmistakable

 as I was prone

to divert in exchange

for a voucher

 or whatever else

 was in unison

with the sound of my little effort

in decline

 for I was the now the metronome

 in autumn fern

 umbrella pine

 a vocal range

broken

 in the order of affluence

so it was just as well I was lost

 on the pathway

 to the waning

compass of theremin and celesta

Oxygen

With a mineral wrath in the absence of oxygen

a crystallized color a quotient of blood

 Here like a yellow iris I riffle flame

 on frozen rock over broken ground

 into icier emancipations

I blister name days farther afield

 I join the hillside horizon

 and cutaway to wind-ruffled

 offices of the heart my

 perimeter clouded

 from view or—given

 my station—meant to conform

Here is the great salutation I exhale on the axis

 Here I eclipse in the welter

 and swarm in possession

 of my temper against

 an irresolute effort

that so mesmerizes

as to bar me from

the quadrant where

I elongate in wingspan

where in daybreak defiance

of breath again I rehearse

according to promise

Palisade

I knew the broadest order of my overturning

in familiar dashes of gold and green

in four-fold welter I eclipsed

and with every tender jostle

too much in my custody

I was nowhere else except

in circles the semblance

or cadence that started

my number down the path

that drives a nation apart

but maybe the boy will

outlive us—the boy I said

to myself as if to dwell

again in the properties

of my possible skin

in undertones of amber—

bottle-base amber partition

I transfix for the fallen

from favor—and other amber

names for the artless

defense I'm enfolded

in amber kept in a capsule

for the unforeseen future

immune inalienable

and without disguise

September

Mirror symmetry in the wilderness.

The marauders with their sirens

and sticks. An astrolabe

for the constellation

of cancer—for the one

true calibrated

mercy of my immediate

and overfamiliar

shadow cast in autumn

fern: hexagonal.

I could no sooner bring

myself to imagine it

was just as well to them

I was disappeared

or barely discernible

along the causeway

than to dwell confined

in the animal recesses

of my vesicular sleep. Only

then am I entrusted

to shelter consigned to

the rattling outer reaches

of my nerve in turquoise

uncovered by lamplight a body

outnumbered by octaves

Congregation

For this episode of the season I fit the sun

inside a box so I can speak for myself

in counterpart bundles that defer

my waking Or else I'm airborne

over the lake figures their locks of hair

in congregation A chimney swift

the meadow patches of mint

aurora intake I'm dangerous

and barely adjacent to faith

in my daylight sobriety

mineral now and multiform

Ten minutes and counting

to the place I emblazon telepathic:

release of my replicant breath

protective shell I'm in defiance

of the sign that tells of the hazard

ahead alive to the midnight

fibers sustaining my pitch

Chanting

marigold ridge in the majesty hour

serpentine rock at home in the air
if only what song can make prosper

or make ripple like agate and onyx

so behold the preposterous flower
bewildered rotation another day

below in the underbrush of long ago

body at dawn and alms for the stranger
in the metronome counting of time

in the toxic emission of lilac and rose

in the unforetold occasions of green

throne of earth reduced to embers

honey and bread in vanishing point

Throne

late afternoon in Houston a shade of ale

in sun-surge in beleaguering

caterwaul chords

and petrochemical distortions

of the atmosphere

that turns a face into wax

into yellow edges

and trapped little tinges of gold

like the skin of a starfruit

*

why bother with this business

of extending the breath

lower jaw in overhang

so that my tongue collapses

like a wounded animal

a grossly swollen

tuft under torch fire

my tribute to the carbon god

*

I led in idol worship the colossal

volume two towers

sloping each at the zenith

almost touching

and because I was given to claw

and hack and chisel

for my second life

through a bolt

of space and air

between the bronze-colored

grid and solar glass

I remained insoluble

only certain of myself

insomuch as suddenly

there was thunder

come to rattle

the cedar trees

and live oaks

come to forfeit

the lavender

and grasses_

February Sketchbook

raspberry patch under cottonwoods and linen

half-light behind the house on Farm to Market

grackles and louder insects in oblique rebellion

arrant windblown sensation and fitful clicking

lapses cast from countless shades of sundown

cenizo field in lavender speckle along the ridge

and mile after mile the nearby line inaccessible

razor wires that barricaded entrance to the park

cicada molts beneath the late summer mesquite

found scattered by the riverbanks at Eagle Pass ~

4. Sign for Bridge

Fable

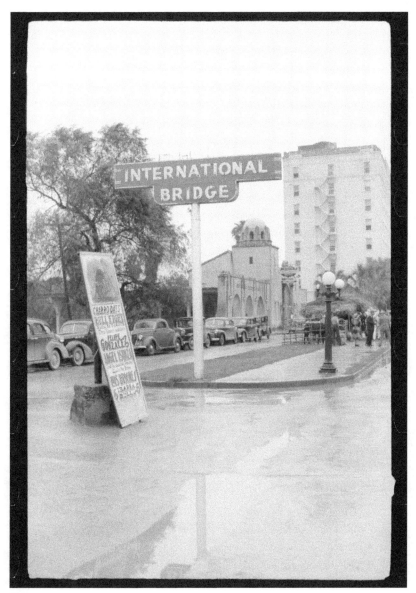

Figure 1

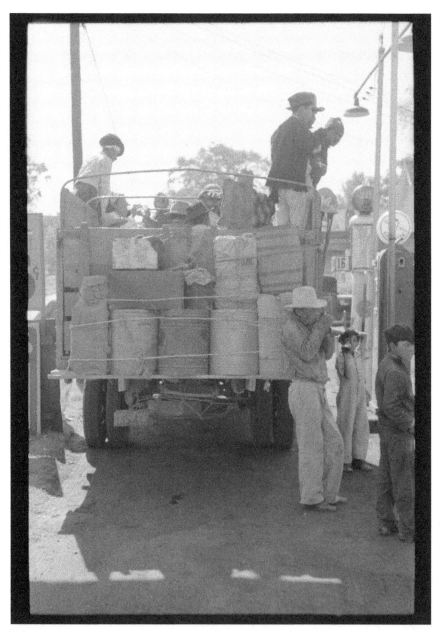

Figure 2

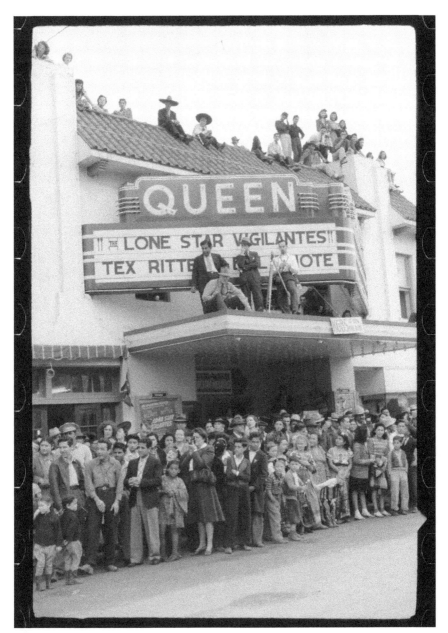

Figure 3

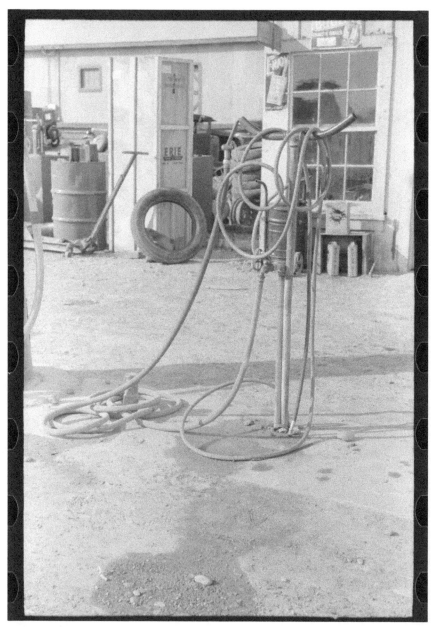

Figure 4

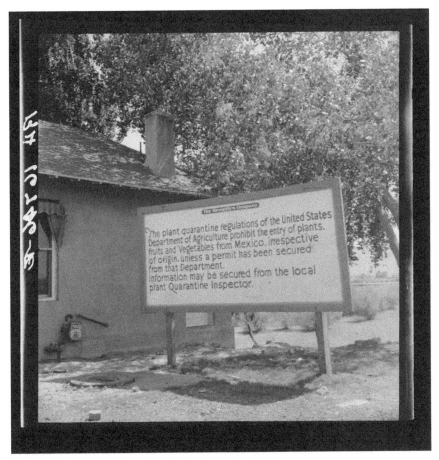

Figure 5

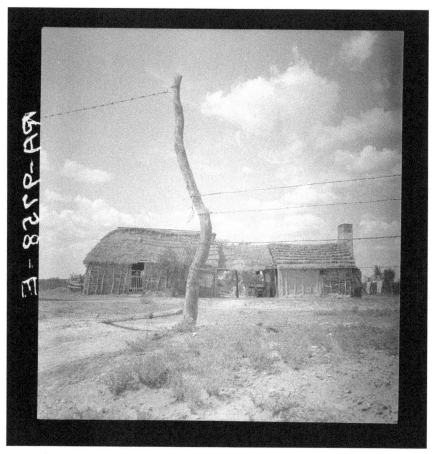

Figure 6

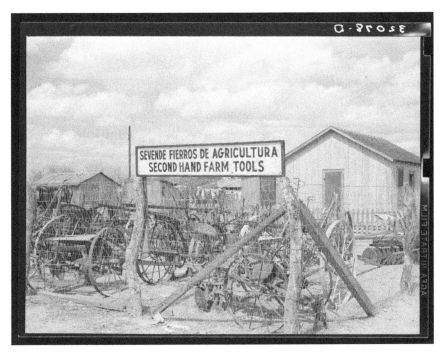

Figure 7

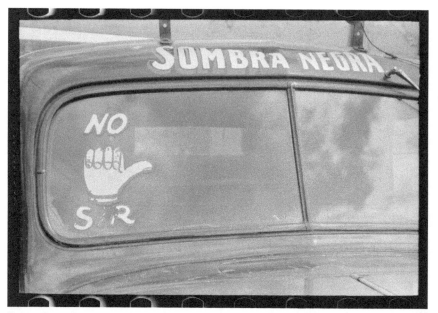

Figure 8

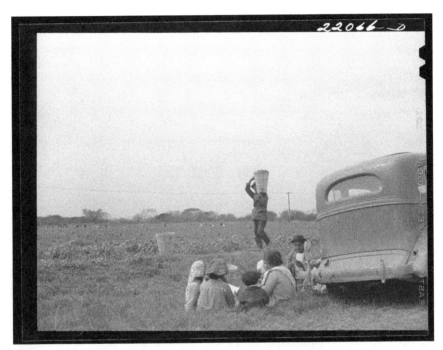

Figure 9

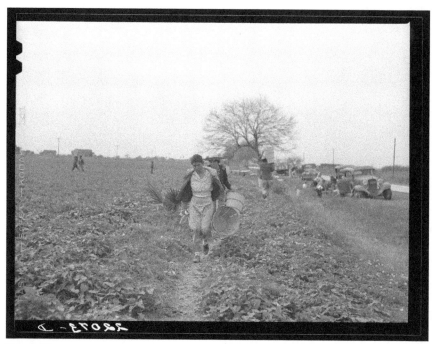

Figure 10

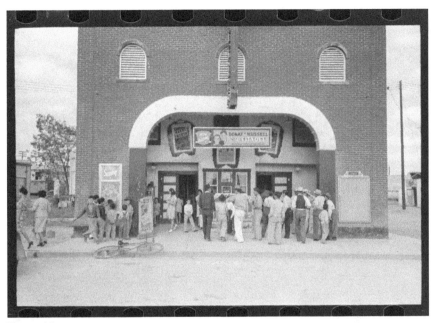

Figure 11

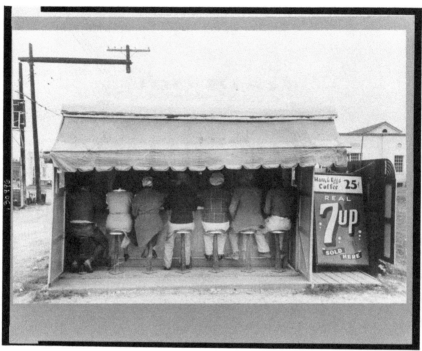

Figure 12

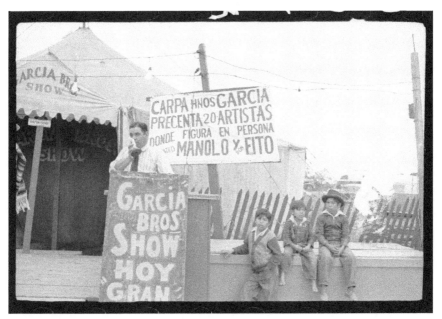

Figure 13

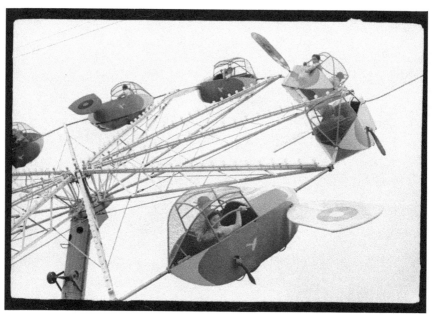

Figure 14

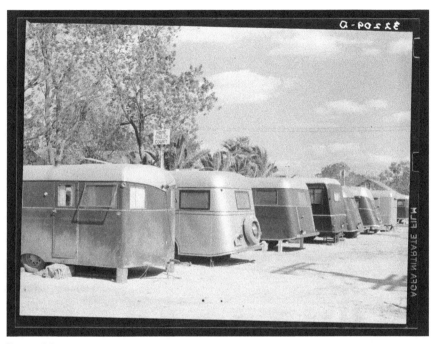

Figure 15

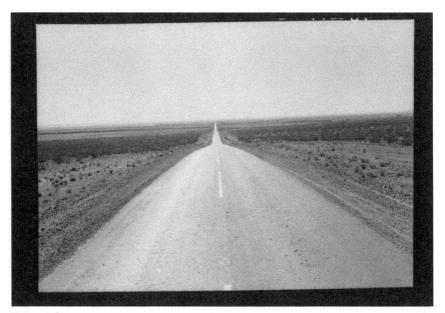

Figure 16

5. Bicentennial Boulevard

Field Guide

Once from a sunset cliff overlooking

 Los Angeles

with my head exploding into iris particles

 the air irradiated

parts of me that served the juvenile delinquently

beloved of a wolf

 pack at once hallucinating

that we levitated over pink billow blue

below even as I was then already an arbiter

of space it encircled us I mean

in ways least resembling an analogy

 all tinged

in the instant I was mind prior to world

begotten by seismic shock by hydrocarbon

igniting eyes phosphorescent of a gray

fox hiding between the torrey pines

and brushwood

clay-clump fox species adaptable to all habitats

of Hollywood don't believe me ask Reed

or Teresa about the bush dog in our vicinity

that it stood for a tutorial of kin

following the flight

a figure made possible of exultant speech

and we crafted declarations of habitat

future persons
so traveling

through time as to figure

hands and limbs with a new

vocabulary of movement

about beast and flower

about our estimates

regarding made things

and saintly misfit styles

of mimicry please don't move. I mention

this now in the same way pale obituaries

pictured the cruelest singer redeemed

in perplexing terms of veneration

submitted by disciples whose hope

was so much a species of nearness

that my voice burned once

today a votive candle for the bygone

another for kingdom's kind

on the edge again of dispossession

Pathway

beat of my heart a pathway cut in sunset rain

 and crisscross panic below the animal sky

alone this far into the battlefield trail before endtime hours

 along the maw of brush under a canopy

 of wooded turns I enter behind the palms

as though it happened rather from another time

 unassailable danger in the alleyway between

 the houses and empty lot glass door

exposed to the felons who still in my intimacy

 still in my neighbor's surveillance humiliation

of men in the shape of a man I was already running

 out of time the other boys all detached

and sun blond in possession of their attributes

 withholding of an element enough

 to cast a spell and prolong the derangement

in the haze of Frampton or Zeppelin and a hit

 of this even Zubiate my friend with me in contempt

but being so lit as to mistake the signs for invitation all

 junior varsity and to the greater purpose

 was their endurance about to burst at the seam

and into the hour of my waking state after brotherhood

but before I got lost again the crawling pathway under cover

Swerve

so the brittle surface of a fingertip estranges a ridge
of my inner hand I make ripple for traffic

swerving like this to resemble a spell of water
or the umlaut flit of cattle egret olive-sparrow

desolate chitter akin to the tap now of aluminum
wind-wall settling from its rafter attachment

or the subaru's underside long after ignition
approaching passing nearer then after

throat slip swallow middle ear contracting
the slide of vibration oblate along a nerve end

off-rebounded first unknown and in suspense
over field affinity brush back with the insect

trill now a tunnel receding in mineral

circumstance above earth untrammelled ebb

of insufficient speech oceanic engineering new

vowels imminent for avian scales and many plosives

possible for footstep on rocks disintegrating in

to finer orders of gravel and silt animato spool

in alternate enfolded overlap and ever since avowing

Time to Wake Michael

long view short

breath wrong

sign tethered

unwinding into

place distended

edge frayed I

am the clinic

of this radius

with my mouth

and cheek

uncertain cell

my genome

survivals

of blood

buried stop

motion

coupling

at the outskirts

that fasten

unfitting

for our neighbors

what they do

there maybe

time for arms

and axes time

for spouses

so given

to lip and uplift

given to spine

and finger

throat and hip

to clavicle

in everything I

rough tumble

venerate in

you this custody

makes possible

a past the solitary

plenitude of twin

time home

in slow descent

the company we keep

Time Insufficient

When austerity is there a siren

haze and hiss whenever the apologetic noise

a clatter tick-tick this

when in everyday direction—left on

Taft from Allen Parkway—

does a minute any longer allow?

•

Of despair Audre Lorde said

it can serve to make intractable—song

even in the indistinct concealment

that drives the law of number and person

—is my self-abstraction any more

or less obscure and how disputable?

•

Here in the meanwhile is

my telling of a scene disfiguring

 slow-motion motive for persons

you could never really reach in time

 I mean it being insufficient to

the near now archaic now faraway

Wind

tilt temper all grievance can you guide this

in a field of the otherwise seen from the curve

of battered grasses beg please with precision

on this valentine earth shade of oat shade

of sand invincible reversing momentum

undulant wheat wave gold feather grain

the horizon is a nervous system wind wails

in high desert song cycle circulating blood

in the animal I begin with a settlement

of extremes between particles that drive

my orbit to oxidize to pacify my twin

mouth name in Mescalero rainless

ripple hill alone maybe the other house

to insulate as stone was to severing sound

from the desiccated oscillating wind is oath

I swear on the remains of the family I am to

a child by long divisions of eight into thirty

seven I carry all five of us this other side

diminishing rust-colored totem the sunlight

Messenger

sightline connected abiding light to mirror light receding

mother's mother night seed cover of land the keeper tends

animals wake by unthreaded mask in green time wealth

thriving child my messenger burn hour for father's father

seed for health out of harm dream house unity listening

honor stranger darkening thread where land is empty of sound

between persons what the dawn says as with marsh and mountain

custody by hand work and light source aquifer glass appearing

a matter of hours universe on the other side of inside amulet earth

nevada latitude expanding ever near newborn eye to open eye

Warning

I meant to acknowledge in timorous chords my voice

below the crawl space so recoiled

I obtained a shape in emergency drill disordered

rush of my signal minted

in glint fraction of a world

my principality in contempt and gladness

with so many callers to welcome

as there were visitors to refuse

involving one of my elders

—your holiness the living daylights

your grace the last resort

your eminence all-cameras-off

all the garbled wartime frequency

warnings in transistor innuendo

even as I made no circle

with the quietest keepers

even as I had no part in the turntable

distortion of our landlocked republic

intoning the exact legacy of pain

committed to memory

despite the exorbitant

distance of my person

in petrified advance now

look what you've done

just look what the interim did

to these lines I retract

in histamine dilation

the idea was this

—I propelled my flexible form

bereft of guidance

each day defiant

the low insubordinate

timeline assigning my opponent

to the horizon and the airwaves

Tunnel

There to my right was the tunnel's wall-work emitting static shock

all hell it must have been to the biomorph evolving

over time. I was parent now to a generation

in the grid system ushering my daughter

across to absorb the aloneness

and rage of human inhabitants who

abandoned the shelter as commanded

by the holy book foretold in the floodlights

from our drone delivery for survival

In the tunnel was the hand releasing her impossible

grip around my emergence I, the mother who

made quiver all fanfare I, the fix

and fracture held to the crystal measure

I was the blood-cell accomplice

contractor and mercenary I was

as oxygen levels dwindled in the desolate

corners every airborne risk I meant

to redeem with liturgical frequency—

or did I decrepitate in brutal contrast

as an aggregate henceforward of air?

The tunnel had returned us to the eruption of plasma

from the sun in particles radiating into Earth's

enclosure the planet's magnetic field

a muddle. Its density increased

now with more particles

that pushed against the satellite's

orbit in atmospheric drag

pulling matter out of the pathway.

The tunnel served once as human shelter but no longer

there was barely enough room now to wonder

in the early hours of the dark whether

the threshold was equipped for us to safely

execute the next pivotal phase to avail a person's

fate in the fury of aerosol droplets

consecutive days by hundred-count

surge unceasing diminished

perimeter between sleep and waking

circles of day in dilation

overtone of crowds in gray

except for the sirens and screens

in that initial contact with the atmosphere

some sweep across the distance

maybe a suggestion to obviate

a second or third attempt to release

myself from confinement

under the striated clouds over

the downtown skyline

Touchstone

whatever the merits were whatever delusions of restraint

 or genesis in the numbering star-clouds

 all for a boy under oath

under night cover given to deviate or dysfunction

 given to the endmost hindsight so now what

 I mean what were the chances

 my castaway

emerging figure inclined to flourish

 over the mainland anyplace palliative of days

I refute in the oscillating pulses of a touchstone

 time I occupied so much as to look away

from the transient physics of this ongoing

 praise pattern

impossible without you

 even if I abide

in the half-expected temperature

 & modulation of my decline

 into despair

even as I ignite in the oversupply

defaced form nothing really

 but the family name for have no mercy

 or mark my word

or my own name makeshift for the deposition

 a trip switch

 to threnody

to mornings of another missing through-line no matter

 the genetic preferences the protein

 needed for immunity

 for second-hand marvels

and remote meetings

 all things antecedent

in the cadence and ferocity

 of a wind-up clock zero fucks to give

or did you come at me crazy

 all search and destroy

 as another day began

 same today gone tomorrow

same sorrow shitshow parading at dawn

 in bone-break and bullet holes

in heart-shaped trinkets little ABC in the ether

 in superable distress in suspension

 each intake of breath oceanic

Season

Season passing from the one encounter I dodge I take cover again

but rarely succeed in reaching anywhere new in the landscape

maybe if I bury the coins for those who live among us

unattainable in the subdivision between citrus

and palm in the lot behind the emergency

care center officials report

a moving situation very quickly

I adapt to protect the citizens

more precise as I influx

when it falls on the government to help

says the bishop on the chief of state

says the county judge on the unvaccinated

says the medical examiner

they who seek asylum do they

carry diseases absent here do

they fill our hospitals with need

for treatment is the answer

in our rage room we've

accommodated a selection of music

for the blood flow

here are the clubs and sledgehammers

for you to break things

every corner of this house for us to break things ~

6. Puente Brownsville–Matamoros

Cover

I was telling you about Emma above the new year

din : neighborhood drunks burned Roman

candles they hailed with slurred tongue in terms

of *masculine endearment* —*mijo*, look—

all the calendar confetti in years per minute

like the pink and white powdered soap

stippled into sooty palms of the little

shitheads in the lavatory of the science

& industry museum I thought to place here

under the papier-mâché Judas effigy

for the messengers of god to dwell beyond

the threshold of sound & light beams

another color 1969 invincible

in amber amulets no cruelty can equate

to Béla Bartók *Pillow Dance* a face

as intimate as loathing on Monday

the knot only a twin is given to untie

now that angels saw these things too

the Manson family rampage my Sunday

insomnia saliva and octaves

in crimson defiance of a bottlebrush tree

behind the house it was for hiding

Room

Feeling knives the microphone to cauterize flesh it amplifies

Crackles the abrasive metal fabric

Blowtorches feedback hold and heel

Throttles and pauses the cord-pull

Lulls to lunge in transmission back seat pocket

Alone the sound crowd

Accumulates the solitary intention of hooded jacket front punch

Zippers the matchstick ignite

Handcuffs the thick slide probe with plastic tie

Zones between foot and huddle

Shrills the retreat from acted upon or was it repeat

Tools the self-animation

Insomuch as the metal scrim

On denim is able to inhale

Skin-howl blister swipe

Caresses and so abrogates as to grip therefore

Larynxes stride and light step

Dry touch enveloping to self-anoint

Tag identify anatomy pulse

Whether pleasure or pain it collapses

Second human shell the cosmos

Automaton guest or X

Feeling that ligaments today in predation

It houses it afflicts it encircles

Facsimile

Bygone paper facsimile unfurling fades to

contain the particulars of time

in the obsolescent measure of weeks

or a day and a lifeworld kind

of drive always fraught

propelling forward a hope

into work and fellowship into after-

wards a wonder unbroken

sound a signal from a satellite

unstoppable diffusion of once

inaudible when I was alone

my head in a haze enough

brandy and coke a dentate

thought a lick of the sense I stand

on a synthesis of what I look at now

I got here slipped of happenstance

I have it all in the red shift

circle a spell beyond Sunday

Monday or Always by touch

and a glow an object cause

or wavelength promise of 1988

in the elongated phrases *Let*

the flame linger low with Betty

Carter upward lifting *make it last*

Thread Time

The line here intended to split the difference

between the vast and beloved. To get

there is to exit the archways & gearwork

emanating from a hollow on the electro-cardio

curve that comes to a halt. This is

to dwell in the chevron length of my body

its labile sensor folding the zone once

inhabited by thread time pursuant.

It enables the filament immersion I'm

to wave-make and buoy in gold

all overlay and forensic mess

or anyway when the mark

points to my belief in the amplitude

or invitation to be suddenly

temperature & tissue not prior

to cause but in beside-like shimmer

Embargo

Wave after wave I recede in the flux I abrade in the drift

on the roads and rivers in the spill I go slack

I buckle from debris and the undertow

in last appeal lost reprieve

my disparaging kin this surrogate heart

and forefather vengeance

now errant in scale

 my household defeats

were no less and too little to further magnify

in fury as I broke light's acuity

and quickened the pace

to unleash my offenses

I was a child but it was time

to recite the defiance and grind

I made no sound or none

at best resembling speech

and I was inconsolable

 it so needed me

to exist I thought later out of sorts

in the seamless pressing

of my mouth to momentum

the hapless little markings

emblazoned on my face

for the sacrament of fire

that terrified the night

on television news

the wartime missing

tagged in acronym

across the stop signs

on second street

 whereas nothing

I knew in daylight could make plain

the displacement part of me

that led in lockers to so delay

behind concrete stalls

and chlorine cover the idle haze

arousing narcosis

Entrance

Palm tree sounding brass a building

ripples in the slant sky

swarming with lifelike angels at war

in the engineered division

of assets Firewall

smoke cloud solar flare drone

I beseeched all things

in the ether rehearsing

the lesson I learned

for dwelling

in the underscore

of my hidden sequence

fit to measure

fit to brandish my weapons

when I ordained

the part of me in error

when I was absent

of ground

for the encounter

or effacement

I had knowledge of

a world ago

birthmark of my person

oblique in opposition

to the cameras I dodge

from the river overlook

all my attributes

now particles of data

converging

above the troubled multitude

that denounces my pedestrian

opulence uncertain

when to attach

when to destroy

I ~ the arbiter

of austerity the cause

of so much unbearable

discernment

examples harmful in extreme

I ~ the enforcer

of actions condemned

independent of my motives

released from the nursery

of what I once thought

when I applied myself

to the letter

divisible by blood

disjoined from the heat surge

I choreographed —or am I

an orphan open to apparition

converging at dawn

before the battlefield

after indignation

and death threats

in my quarantine

when I seethe in the unrelatable

insofar as I levitate

in light that sustains me

and you submit in the end

to my hammerlock

my salacious command

I was here first I was

so in possession

of my senses again

as to survive the toxic propositions

but even seemingly victorious

did I underestimate the consequences?

Legion

In the domain we built where speed

prevailed for our legion

overrunning the place

by popular demand

our followers

in the dark early hours

awoke to a world

in withdrawal

from any tenuous

basis in fact

none in logic

eroded by deserts

menaced by flood

they were prone

to be hospitable

to dogs and their own

the dying part resolved over time

but for waiting outdoors

at the gateway

to hazard new days

in the wrangle

and undertow

that separate a child

from our leave-taking

Oblation

shade of grapeseed oil and lime from the northern balcony

overlooking calle Tonalá brightness

breaking through a haze

from overcast containments of midmorning sun —a siren

part dog whistle part woodwind it was

the time of knives

the key of whetstone and revolutions per minute

any portrait of myself in the end

an iteration of the obvious

as though it mattered that anyone could surrender

as I had

 to so much of the source

or whatever remained of its depleted shape

a residue of sound

like an orphan

like a mind he said was absent of image

in exile

an enigma

a belligerence

in servitude to the principality of speech an oblation

dear from the notebook yes

from the notebook no for nobody

this hypnosis cast in sky blue billows of dust

the solar flare an open hand

the particles of rule in supremacy's

forcible curriculum a certain unease

for you in the camera of all things

October reflex of light

to the ravines of genesis

to a time I was lifted

from sleep by commands

to do with rope and ladder

to do with de Kooning's

expulsion end of story

even I knew the threat

that surrendered my immunity

four times to the attendant fold

in the open hours hour

for the taking hour

for the advocate hour

for the record still another

hour I suspect was for clemency

Particle

Before my memory was of a mind to conflate

the proper names and I was Félix

or Fidel or overexposed

by the solar event

body obliged to disentangle

today from the persistent

microplastic order

in multiples

of metric tons along

the gulf coast

in concord with the slow

motion approaching

debris of time

it takes to fill

my lungs I was the agent

of this diameter

a tiny particle

in the recess

of waterways my

one lung a target

the other a riot

together a specimen

of the power

to surge

endanger

downdrift

floodtide

undercurrent

expanding

my habitat

of effluents

to convey

in sound my

concerted effort

because always

emergent

within the radius

of my station

Renegade

for us to appeal not this day now of insufficient time

but as with each new mark no matter the noise

made known for us to move apologetic

keeping elsewhere for a person to decline

or disappoint for us to over-trust

the forecast machinery in plain

sight I was given to forget

my birth name in consent to other

needs most recent even as

my will was of another

nature failing at the fringes

in syllabic disturbance I was

yet to mine the authority

afforded the renegades

against the immense panorama

consumed in secret suspicion

even after my triumph

on the side of the number

unsettled account of anything

or anything else I was spared

as if barely discernible

Scorpion

From the entitled side of the horizon
you could sort of tell whether

it was cobalt or steel
I specified and erased

for I was embattled
with my orbit on display

the retelling of a person
—a conjuring trick

Now missing were the cobalt
lines in crosshatch

and out of true was
the metallic shade

to fascinate or bedevil

the stranger disappearing

already to the touch

as Earth from my orbit

or like the gleam of Venus

that led to the consequence

of my cards Atlas

 Ladder Scorpion

an order of mind so weightless

I abandon my lot for the blaze

now receding because I am helium

Birthright

Then it was time to forget the rodent conspiracy

until again I am walking in place It had

for hindfeet the human attributes of limberness

and motility It had for all its oily patches

of fur for all the animated machinic

articulations of fat and bone its Candide

overture outburst its depressive

position speech a species of murmur

no more than to suggest something

of its power to possess and outlive us

its refutation of my birthright and habitat

its capacity to disturb and expropriate

this night shift dwelling near collapse

with its omnipotent incisors my heredity

Song

In a separate system of loyalty

finite stars from the farthest

galaxy that come into view as

I'm adrift of myself or someone

else in the direction of one

uncertain form of refusal one

degree of whether to agitate

from the wounded place

my species of animal yowling

that allows for the fable north

and south for the X and Y

of my genetic chances

stone under wave an ocean

cast in the service of sky

turned madly protective

of the elements in my need

to dissemble the slow modus

of wax from the episode's

great catastrophe of debt

percussive reverence for

ken clay shift spike

hill alive to the centuries

my face in glass succession

I serve as the failing wit

even as I hazard upward

to apprehend what was

never of my other life

or ever once and for all

The Color

of midnight sapphire

applied as if to reorder

the sky when flares cast

us from illuminated half

circumferences into

the highest inhale ~

Figures

10 Arthur Rothstein (1915–1985), Brownsville, Texas (vicinity). Bean harvesters on large farm, February 1942 (LC-USF34-022073-D)

11 Russell Lee (1903–1986), Waiting for the movie to open, Sunday afternoon, Pharr, Texas, February 1939 (LC-USF33-011978-M4; LC-DIG-fsa-8a25144)

12 Russell Lee (1903–1986), Hamburger stand, Harlingen, Texas, February 1939 (LC-USF33-012002-M2; LC-USZ62-130996; LC-DIG-fsa-8a25259)

13 Arthur Rothstein (1915–1985), [Untitled photo, possibly related to Mexican show at carnival, Brownsville, Texas, February 1942] (LC-USF33-003692-M1; LC-DIG-fsa-8a13762)

14 Arthur Rothstein (1915–1985), Brownsville, Texas. Carnival ride, February 1942 (LC-DIG-fsa-8a13748; LC-USF33-003689-B-M2)

15 Russell Lee (1903–1986), Trailer camp, McAllen, Texas, February 1939 (LC-USF34-032209-D; LC-DIG-fsa-8b37275)

16 Dorothea Lange (1895–1965), U.S. No. 54, north of El Paso, Texas, One of the westward routes of the migrants, June 1938 (LC-USF346-BN-018271-C; LC-DIG-fsa-8b32413)

The black-and-white photographs comprising the visual essay "Sign for Bridge" are from the Library of Congress, Prints & Photographs Division, FSA/OWI Collection, designated by "LC" and the corresponding reproduction number. For information, consult the U.S. Farm Security Administration, Office of War Information Black & White Photographs (http://www.loc.gov/rr/print/res/071_fsab.html).

Postscript

These pages are beholden to seasons in the Rio Grande Valley, Texas, and to my place as a guest among visitors and migrants in Reynosa, Tamaulipas; to those who shared their stories of affliction, faith, radiance, and dignity. My book's title owes a debt to the writing of George Oppen, to the promise of his lines as though in reference to the Texas-Mexico borderlands—a rekindled uncanny momentum that would "make the poem an object. Meant form."[1] In *Meaning a Life: An Autobiography*, Mary Oppen recounts a dream that had been troubling George and that led him again, in Mexico after nearly a decade of poetic silence, to the practice of making. In the dream, Oppen and his sister had been "going through his father's papers after his father's death. In a file marked 'miscellaneous' was a paper entitled 'How to Prevent Rust in Copper.'"[2]

Oppen's rust-in-copper dream ignites a system of analogies that connect material, scale, craftsmanship, and the indwelling of language, with the disavowal of any meaning or purpose that would claim to precede experience. Thus my desire for a lyric of breath, landscape, and time in the key of "petrified unrest"— looking and listening of the kind Walter Benjamin perceived as "sundered from the customary contexts of life."[3] Made audible here is a surrendering to other sudden horizons, to the strata of mineral life, so transforming perceiver and vicinity, as by a spell in which a person aches to inhabit a magnitude beyond the individual.

1. George Oppen, *The Selected Letters of George Oppen*, edited by Rachel Blau DuPlessis (Durham, NC: Duke University Press, 1990), 47. ["To Mary Ellen Solt, February 16, 1961"]
2. Mary Oppen, *Meaning a Life: An Autobiography*, edited with an introduction by Jeffrey Yang (New York: New Directions Books, 2020), 202.
3. Walter Benjamin, "Central Park," in *Walter Benjamin: Selected Writings*, vol. 4: 1938-1940, edited by Howard Eiland and Michael W. Jennings; translated by Edmund Jephcott (Cambridge, MA: Harvard University Press, 2003), 169. "That which the allegorical intention has fixed upon is sundered from the customary contexts of life: it is at once shattered and preserved. Allegory holds fast to the ruins. It offers the image of petrified unrest."

Carbonate of Copper gives voice to unsettled stories from the past, as well as to present-day experiences of custody and displacement. The poems serve as a wager on what it means to lend sound-form to the principle of hope; not "the conviction that something will turn out well," as Václav Havel reminds us, "but the certainty that something makes sense, regardless of how it turns out"—or not only, that is, "because it stands a chance to succeed."[4]

The odds are those of survival, as when Audre Lorde spoke not of "mere existence, which is the province of the walking wounded and the walking dead, but an active quality of living[,] . . . the ability to consciously draw one breath after another, to move and to teach and to find both the power and joy relative to our lives."[5] So enabled, the poems aim to make visible the infrastructure of militarized surveillance and its detention complex but also the aspiration to justice and mercy, the resilient self-organized order of time for migrants awaiting passage to the other side of the dividing line.

Carbonate of copper is a mineral found in azurite and malachite, a color medium that had a discernible impact on art during the first phase of globalization, the ensuing colonial enterprise, and systems of extraction. It was less desirable than the deeper ultramarine made from ground lapis lazuli, but Renaissance artists and patrons nonetheless prompted a market for the blue derivative coveted for use in tempera and oil pigment.[6] As a guiding figure, carbonate of copper informs the poems, insofar as I animate material realities to trace entanglements in the web of life; and I welcome language as substance subject to change, as a medium similarly prone to chemical reaction. The blue powder pigment serves my purpose, too, as a form of sorcery: one that would ward off those who deal in injury of the already dispossessed.

In these widening circles, I bear witness to the dark night of the now and the bygone, to family sorrows past linked to hazards today in the search for asylum. I synchronize with scenes along the U.S.-Mexico border attuned to the realities of migration as warped by jarring political vitriol and its commensurate media pitch on the eve of election day. Attentions turn here to the forced relocation of peoples, the COVID-19 death toll, the staggering menace of illiberal rule, the meanings of home and eviction, and my personal debt to artistic forebears and cultural memory. I account for the uncounted, those excluded from belonging, in voices that tell the cruel fortunes and joyful vitality of human and nonhuman life-forms.

4. Václav Havel, *Disturbing the Peace: A Conversation with Karel Huizdala* (New York, Vintage, 1991), 181–82.

5. Audre Lorde, *Dream of Europe: Selected Seminars and Interviews*, edited by Mayra A. Rodríguez Castro; preface by Dagmar Schultz (Chicago: Kenning Editions, 2020), 63.

6. Michael Baxandall, *Painting and Experience in Fifteenth Century Italy: A Primer in the Social History of Pictorial Style* (Oxford: Oxford University Press, 1988), 11.

Notes

Night Festival. In the solitude of late winter 2021, awash with a numbing wonder, a diminishment under the dawn expanses of the West Texas desert, in weeks following the severe weather events that led to a statewide power crisis, to scarcities of water, food, and heat, and ensuing death for hundreds of the most vulnerable; in the nights at last following my first dose of the mRNA COVID-19 vaccine, I experienced a series of dreamtime visitations from my deceased father and mother. "Night Festival" covers a geography, one of family displacement—Bogotá, Los Angeles, Buffalo—in order to reflect the enormity of a moment that so excites one's imagination as to reach a radical impasse.

The feminist philosopher Joan Copjec defines this proximity as "an affecting nearness by which ego feels amplified: more than one with itself because capable of being other than itself," an "intimate passivity" compelled to "remake its relation to others."[1] So the poem provides a scene for me to argue with the dead and to side with the undead in accounts of the knowable, the limits of a self in sound, the horizons of doubt in the keys of consternation and amazement. It relates a childhood fantasy formation about venipuncture, a substitute for early anxieties about imminent harm, doubling in a struggle to comprehend the exorbitant loss of life in the present, and to name the desperately irrational, tumultuous, and intolerable pleasure of a son's attachments.

Sign for Bridge: Fable. Speculative worlds emerge from a past in neighboring pictures inclined as though for the future's sake. Drawn from photographs in the Library of Congress, the visual sequence is composed of lesser-known images by legendary documentarians, Dorothea Lange (1895–1965), Russell Lee (1903–1986), and Arthur

1. Joan Copjec, "Sexual Difference," in *Political Concepts: A Critical Lexicon*, edited by J. M. Bernstein (New York: Fordham University Press, 2018), 202.

Rothstein (1915–1985), depicting life in the Rio Grande Valley and around El Paso–Juárez on the Texas-Mexico borderlands between 1939 and 1942. The photographs are intended to evoke an archive of feeling, a fable that telescopes between the historical past and the political imagination of our uniquely distressing present to which the images serve as testimony.

Room. *Once we thought the ground was everlasting—but even long before it disintegrated, already we were given to foreboding, to dissociative states of fear and despair.* "Feelings Are Rooms," is a series by Kabir Carter, a sound artist whose work enlivens architectural space by means of bodily interactions with acoustic media, including microphone, mixer, and loudspeakers. During one such performance at the Milton Avery Graduate School of the Arts at Bard College (2018), I drafted notations that, as with the sentence here in italics, would later serve to give voice to my own unlearning, to forms of sonic intimacy, to the limits of my amplitude, and to a refutation of the present as a preordained horizon.

Acknowledgments

The John Simon Guggenheim Memorial Foundation, with its invaluable support and encouragement, made the completion of this book possible.

I'm supremely grateful to Richard Morrison and Fordham University Press for the unwavering commitment and care.

My thanks to Tim Roberts for the editorial care of these pages and to the following editors and publications for featuring earlier versions of these poems:

Academy of American Poets: Poem-a-Day (Sherwin Bitsui, Rosa Alcalá): "Room," published as "Feelings Are Rooms"; "Night Festival"

Action Spectacle (Timothy Liu, Adam Day): "Speaking Part," "Impasse," "Macula"

A Perfect Vacuum (Judah Rubin): "Touchstone," "Tunnel," "Remainder," "Season"

Arrow as Arrow / Broadside Portfolio #1 (Michael Slosek, Luke Daly): "Thread Time"

The Brooklyn Rail (Anselm Berrigan): "Immune," "Messenger," "Swerve," "Wind," "Vehicle," "Grassland," "Facsimile," "Birthright"

The Canary 7 (Joshua Edwards, Anthony Robinson, Robyn Schiff, Nick Twemlow, Lynn Xu): "Field Guide," "Lung Compliance," "Witness"

Chicago Review (Steven Maye, Hannah Brooks-Motl, Kirsten Ihns): "Carbonate of Copper," "Residence," "Grayscale," "In Person," "The Color"

Dolce Stil Criollo 5 (Christopher Rey Pérez, Gabriel Finotti): "Cover" (Refúgio), Embargo (Embargo), "Entrance" (Entrada), "Legion" (Legião), "Oblation" (Oferenda), "Particle" (Partícula), "Renegade" (Renegado), "Scorpion" (Escorpião), "Song" (Canção), "The Color" (A Cor). Portuguese translations by Daniel Machado.

Hampden-Sydney Poetry Review (Nicholas D. Nace): "Citizen"

Harper's Magazine (Ben Lerner): "September"

Intimate confession is a project, Inventory Press, 2024 (Jennifer Teets): "Oxygen,"
 "Throne," "Macula," "Congregation," "Hangman"
Michigan Quarterly Review (Marcelo Hernandez Castillo): "February
 Sketchbook," "Warning," "Palisade," "Anyway," "Fugue"
Social Distancing (Alejandro Garcia Lemos): "Time Insufficient"
Overo, *Waiting for the End to Begin,* 2022 (Overo members are Lindsay Minton,
 guitar and vocals; Brendan Stephens, guitar and vocals; John Baldwin, drums;
 Mercy Harper, bass): "Lung Compliance" and "Witness" written and read by
 Roberto Tejada
Oversound (Samuel Amadon, Liz Countryman): "Time to Wake Michael"

•

Warmest gratitude to an intimate circle of fellow writers whose generous response and
insight allowed me to forge clearings, hidden pathways: Rosa Alcalá, Anselm Berrigan,
Joel Bettridge, Forrest Gander, Alan Gilbert, Lise Goett, Hoa Nguyen, Dale Smith,
and Matthew Stadler. I delight in their company and the uplift they offer, along with
that of others confirmed in these pages: Esther Allen, Celia Alvarez Muñoz, Cecilia
Ballí, Susan Briante, Diana Delgado, Chitra Divakaruni, Kristin Dykstra, Joshua
Escobar, Amanda Ellis, Matt Flores, Nick Flynn, Amy Gerstler, Carmen Giménez,
Renee Gladman, Ramón Gutiérrez, Raquel Gutiérrez, Lalitha Gopalan, francine j.
harris, Tim Johnson, Fady Joudah, Ann Lauterbach, Tim Liu, Natalia Molina, Chon
Noriega, Alex Parsons, Daniel Peña, Christopher Rey Pérez, Margaret Randall, Peter
Ramos, Cristina Rivera Garza, Reina María Rodríguez, Michael Snediker, Stalina
Villarreal, Dorthy Wang, Rachel Weiss, Ronaldo Wilson, and Monica Youn.

•

Curated by Jennifer Teets, *Carbonate of Copper* was an exhibition, shown at Artpace,
San Antonio (May 19–August 28, 2022), named after the title poem in this collection.
The poem was included as a wall mural among a gathering of international and Texas-
based artists whose work incorporates the particulars of "circuitry, flow, foundation,
and cultural inheritance, particularly in relation to infrastructure, the environment,
and geological time."

•

Special thanks to Brian A. Strassburger, S.J. and Louie Hotop, S.J., for providing a welcoming place for the visitor to observe solidarity in practice among migrants and asylum seekers in Reynosa, Tamaulipas.

•

I'm thankful for the opportunities to present from or devote time to this work: Tim Johnson and Caitlin Murray (Agave Fest, Marfa); Laura Hughes and Edwin Smalling (Basket Books); Kenneth Reveiz (California Institute of the Arts); Tessa Bolsover and Michael Cavuto (Duke University); David Politzer and Ida Soulard (Fieldwork Marfa); Sylvia Georgina Estrada and Julian Herbert (Feria Internacional del Libro Coahuila); Guadalupe Nettel (Fiesta del Libro y la Rosa, Coordinación de Difusión Cultural UNAM); Chitra Divakaruni, Rich Levy, Krupa Parikh, and Sanjay K. Roy (Jaipur Festival Houston); David Dove (Nameless Sound, They Who Sound); Jeffrey Pethybridge (Naropa University, Allen Ginsberg Visiting Fellow); Diana Delgado (Poetry Center, University of Arizona); J. Michael Martinez (San Jose State University); Joshua Escobar and Patsy Hicks (Santa Barbara City College, Santa Barbara Museum of Art); Aristotle Johns (University of Utah).

•

This book is for Michael Bryan, whose company, laughter, curiosity, and grace make hopeful the days of a lifetime.

Roberto Tejada is the author of poetry collections *Why the Assembly Disbanded* (Fordham, 2022), *Todo en el ahora* (2015), *Full Foreground* (2012), *Exposition Park* (2010), and *Mirrors for Gold* (2006); as well as art and media histories that include *Still Nowhere in an Empty Vastness* (2019), *National Camera: Photography and Mexico's Image Environment* (2009) and *Celia Alvarez Muñoz* (2009). The recipient of a John Simon Guggenheim Memorial Foundation Fellowship (2021), he is the Hugh Roy and Lillie Cranz Cullen Distinguished Professor in Creative Writing and Art History at the University of Houston.